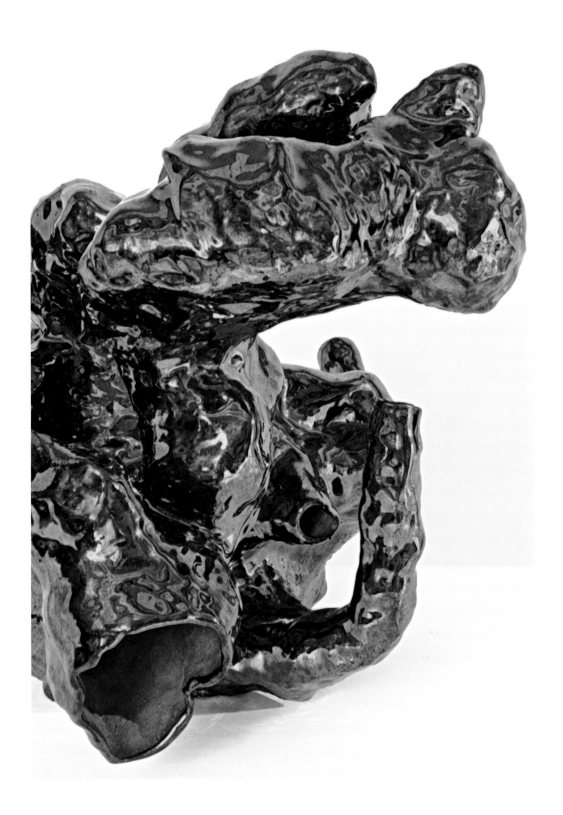

ARLENE SHECHET

BLOW BY BLOW

IAN BERRY

THE FRANCES YOUNG TANG TEACHING MUSEUM AND ART GALLERY
AT SKIDMORE COLLEGE

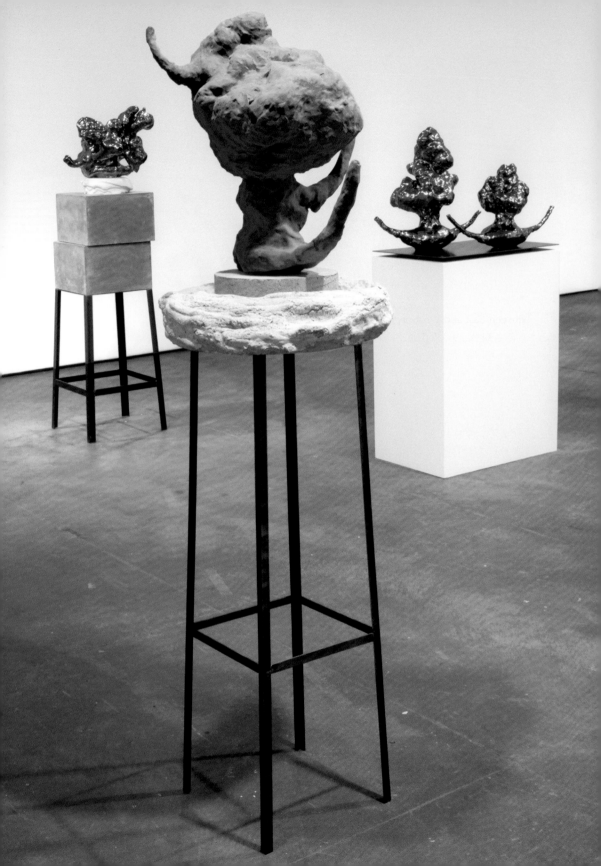

BLOW BY BLOW

A Dialogue with ARLENE SHECHET by Ian Berry

Arlene Shechet's recent glazed ceramic objects float, twist, and puff-up atop stacks of unadorned concrete, plaster, wood, and steel. While Shechet has worked in sculpture for over two decades, these new works shift away from her earlier explorations of iconographic Buddhist imagery toward more abstract forms and combinations. Confounding any single reading, they hover in the fertile space between East and West, secular and sacred, and modern and ancient.

Shechet's modeled surfaces demonstrate how clay mirrors the artist's touch. Her objects bear the mark and memory of her hands. The sculpture's bulges, hollows, spouts, and holes evoke bodily features and, as the artist notes, are "suggestive of the curving forms found in classical Indian sculpture." By coating the clay with eccentric color combinations and metallic glazes—created with an experimental disregard for traditional firing temperatures— she not only fractures the objects' surfaces but also undermines any single association with nature. Seeming to expand and deflate with breath, Shechet's dynamic works continually transform as the viewer changes perspective, reappearing anew moment by moment.

IAN BERRY: As an artist, have you always felt you were doing the thing that wasn't in?

ARLENE SHECHET: I hope so.

IB: You like that place.

AS: I like that.

IB: It can be lonely.

Installation view, *New Work*, Elizabeth Harris Gallery, New York, 2007
In foreground: *Good Ghost*, 2007
Ceramic, cast concrete, steel
Collection of Dennis Freedman

AS: I am okay with that. Being marginalized represents an opportunity. If you are doing exactly what's in, you are on your way out.

IB: Do you think of your viewers when you work in the studio?

AS: I am already the audience. When I make the work I get in a place where I allow myself to let the work happen, so my conversation is with the work. I'm like a medium to let the work pass through me, and I'm responding to what's there.

IB: If you had no show, you would still make the things?

AS: I'd still make the things. But I love the process of having exhibitions. I like that feedback, the spaces; I like moving things around, revisiting the pieces in new contexts. I think art needs the world. If people can see something and have it grow in their minds or bang up against their emotional state, then that makes me happy.

IB: What do you think of the idea of having faith?

AS: I think everybody has faith, unless they are deeply depressed. By nature I am a pretty optimistic person, and yet I feel that things are fragile. The Eastern way would be to say everything is in transition always. And the way to deal with that is to pay attention to how amazing things are.

IB: How did you learn that? Most people don't have that kind of clarity about things.

AS: I can't necessarily live it as well as I can say it!

IB: When did you start thinking about living your life that way?

AS: I've been lucky enough to have a natural flow of opportunities and ideas. I made one rule for myself early on: if you think it's not interesting (like the things that give you an immediate repellent reaction), don't immediately turn away. Those might be the places

that create openings. That rule made me aware that everything has possibilities. For instance, about fifteen years ago I was using blue and white in my paper work to refer to architectural blueprints, and this made me suddenly sensitive to blue-and-white porcelains. The way the glazes overlapped with how I was trying to bleed blue into my paper works. I started to look at porcelains from China, Flow Blue from England, Delftware, Willowware, a vocabulary of things both Eastern and Western that I had always dismissed as boring. The idea of the bleed, and impregnation, all that was already happening naturally with the paper had a huge history in ceramics. I had earlier come to believe the vase is a domestic form of sacred architecture—all of these thoughts expanded my relationship to ceramics and, in turn, inspired the installation *Once Removed.*

IB: At art school, did you know you were a sculptor right from the start?

AS: Yes. I think it's an innate predisposition. I like dealing with the physical world.

IB: Where did you go to school?

AS: I went to graduate school at RISD. And I went to undergraduate at Skidmore and finished at NYU.

IB: You grew up in New York?

AS: In Queens.

IB: Was art part of your family?

AS: My mother was a homemaker but she painted in a studio in the basement of our house and I would go to the art supply store with her—I loved the smell of the art supply store. I was always doing drawings or making things.

IB: Did you grow up with religion?

AS: I grew up Jewish in a fairly observant family. I learned Hebrew, partook of the traditions and felt like I could transition into the world carrying that faith in my back pocket, while totally rejecting it at the same time. After graduate school I listened to Alan Watts on the radio in my studio in Boston for three years. I met my husband Mark during this time. He had sought out Buddhism in his twenties and brought more of that information into my life.

IB: Do you think of yourself as Jewish or Buddhist?

AS: I think of myself as Jewish but don't see any contradiction in paying attention to a lot of different belief systems. I like the idea that we all have this stuff that we're given. Pass it on and let the next generation deal with it however they like.

IB: Were you afraid to bring religious imagery into your work? That wasn't a popular theme for art in the early nineties.

AS: Right. Well, my experience with the Buddhas—those really happened by accident. I was fishing around for a new way to work using wet plaster without an armature. I made a blob and thought it looked very roughly like a Buddha. I wanted to work with time as a material element and found myself receptive to associations. There was the Buddha. When a friend stopped by the studio, the look of horror was profound. First I got scared, then I got interested.

IB: Because it was a religious symbol?

AS: Actually, I was thinking of it more as just a form at first. People started coming to see them in 1993, and their embarrassed reactions gave the pieces more content. It made me think how strangely limited the art conversation can be. I was surprised to find myself in the dialogue about religion, but then I welcomed it. I still cringe

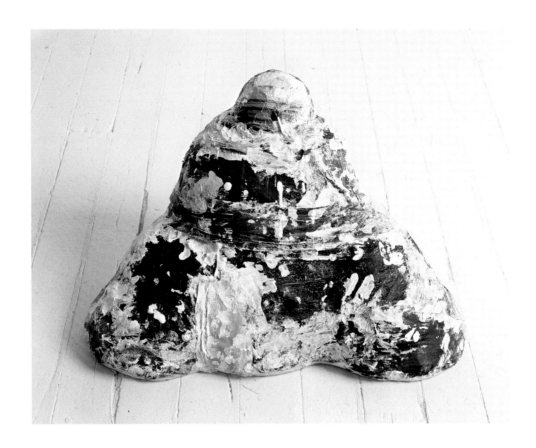

if anybody starts talking about the spiritual in art, though. There is a basic problem with vocabulary.

IB: The word spiritual is pretty abstract. You are for faith?

AS: I am for the search, which I see as a search for meaning. Buddhism overlaps quite well with studio art because a lot of the ideas—of mindfulness, time and attention—are relevant for the state of mind essential for studio practice. These pieces were very much process pieces.

IB: Are those bold colors painted on?

AS: All of the colors embedded within the pieces are acrylic paint

Mountain Buddha, 1994
Hydrocal, acrylic paint skins
12 x 20 x 12"
Private Collection

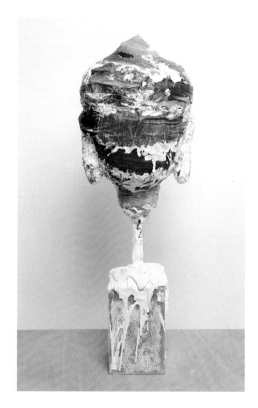

Fleeting Head, 1995
Hydrocal, paint, steel, concrete
28 x 11 x 10"
Collection of Mark Epstein

skins that I had been experimenting with from an earlier series. I embedded them in the pieces as I was making the plaster forms. They provided both structure and surface. When people started to refer to me as the person who made Buddhas, I felt uncomfortable. I wanted to make things that were more about getting inside of the Buddha, more about what it was like to be alive and breathing. You can look into the openings of some of my recent work and see inside the material into the hollowness which relates to the breath.

IB: Talk about being a woman artist with a family in the late eighties and nineties, when a lot of art concerned identity. Women were starting to push harder for shows, and institutions were responding very slowly. How did you fit into those conversations?

AS: I wrote something for the journal *M/E/A/N/I/N/G* about being a mother. They had a whole issue about motherhood. I was a little bit angry all around at that point, because when I was pregnant, I remember feeling that being pregnant meant taking yourself out of the conversation.

IB: So you didn't feel welcome into some of those conversations because you chose to have a family?

AS: I just put my head down and used whatever time I could find for my studio. I feel fortunate to have been able to maintain my studio life. Having a family is a complicated business.

IB: What were you looking at then?

AS: Richard Tuttle and Myron Stout. I bought Stout's Whitney Museum catalog for a dollar on the sale table. The boldness and quietness

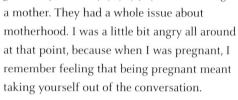

10

of his work got to me. Richard Tuttle had a show at Brown University when I first started teaching at RISD. His relationship to materials and scale were important to me. Elizabeth Murray gave a moving and energizing talk at RISD and even talked about having kids. I was thinking about Lee Bontecou and her work with holes, leather, and wire. I was already attracted to Eastern stuff, so Francesco Clemente and Luigi Ontani were interesting to me as Western artists who were accessing Eastern stuff.

IB: What else was happening in New York?

AS: I remember Holly Solomon Gallery on West Broadway and walking in and seeing an installation by Judy Pfaff. She was interesting to me from the point of view of using many different materials, using the architecture. I remember that space very distinctly, and more than I remember any of Judy's marks in there, I remember how the space held it and how she pushed out against it. I thought that was quite fabulous.

 I remember Kiki Smith's show of figures at Fawbush Gallery. That work had a broad language: it was not pinned down to one thing. It was figures, but it was also some stuff on the wall. She was having a good time and also dealing with a feminism I could relate to because it was not so strident, even though it was tough. It was beautiful, even though some people would call it ugly, and that has always been attractive territory for me. A few years later I was in a funky group show in a vacant space in Tribeca. It was the first time that I had shown any of the Buddhas. Kiki came by, bought one, then called me up and invited herself for dinner. She said she was interested that I was making such unfashionable handmade stuff. It turned out that she had a lot of interest in the decorative arts, as did I, so she was turning over my dishes to see what I had, and I had lots of weird stuff. We immediately bonded.

IB: There seems to be a renewed interest in the handmade right now in contemporary art.

AS: I think we are always at that moment, but I think you're right, there is a language now that is completely obsessive. Some work is obsessed with touching things in just the right-wrong way. Things that look really relaxed, even trashy, reveal just as much obsession with craft as the overly refined object.

IB: What about humor in your work? Your recent works are funny and they're awkward, and their awkwardness has humor. They look too big, too fat, too bulgy, too lopsided. What's the power in that kind of awkwardness or embarrassed feeling?

AS: Embarrassed, that's a good word.

IB: Some of your pieces look a bit embarrassed to be on view.

AS: Not embarrassed to be on view, but working to embarrass whoever is looking at them. Almost all of the recent pieces are top-heavy, in a state of imbalance, precarious, threatening to fall over. Humor is really important for me, because I feel that's where the fragility comes in.

IB: Because laughing is a way of releasing tension, or a way of showing vulnerability?

AS: The laugh in very literal terms is part of breathing, so the laugh is another kind of breath, another exhale; then the laugh is also uncomfortable, it's about recognizing something. I don't think you laugh at things if you haven't connected to them, so you're connecting and you're pushing away. It's this push and pull that I am interested in. It is ugly and beautiful, it is the very strong and slightly pathetic.

IB: How do you make an object ugly?

AS: That's the struggle when I am in the studio. I make things and then I throw them out because they don't hit the mark, that's

basically what I do. I am dealing with an organic vocabulary of forms, so if it goes over the edge and looks a little too nature-like, I have to throw it out. I insist on the forms not being pinned down. They have to be hybrids to be successful.

IB: Do you make drawings beforehand?

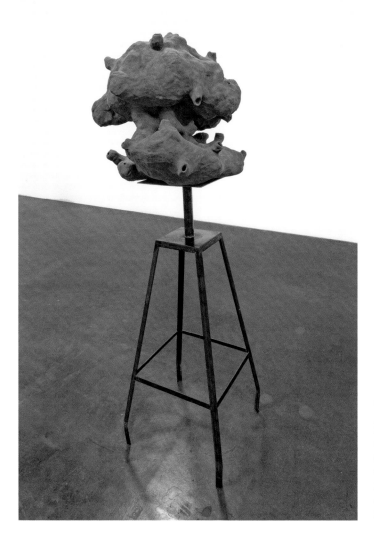

What I Heard, 2007
Glazed ceramic, steel
58 x 19 x 20$^1/_2$"
Nerman Museum of
Contemporary Art, Johnson
County Community College,
Overland Park, Kansas; gift of
Marti and Tony Oppenheimer
and the Oppenheimer Brothers
Foundation

AS: I try not to, I don't want to. That's one of the interesting things about working with clay: it's basically a 3-D drawing material. The clay is soft and mushy. I build the pieces bit by bit so I'm working the inside and the outside at the same time. This happens slowly over a period of months, so my relationship to where the form wants to go constantly changes. I am making things that are hollow, I am making things that are hard to stand up. The scale is actually very difficult——they're big and so they definitely have lives of their own. That doesn't mean I don't start out with some idea, but I don't want to pin it down in advance.

IB: The way you play with and rearrange the parts of your bases is an interesting way of continuing that unfixedness.

AS: The potential exists to change and it is my privilege to use that potential. I'm not sure if I think of them as bases anymore. Perhaps in the future the ceramics won't even be on top in the sandwich of materials. Bases are the eternal problem of the sculptor. Years ago, I had a footstool collection that I had found on the street, and my kids were falling all over them. Mark said, "Get those out of the house," so I brought them down to the studio and then every time I made a Buddha it sat on one. That was the solution for the Buddha bases. The ceramic pieces feel incomplete without some kind of architecture. The bases provide that.

IB: You mentioned that the ceramics are hollow.

AS: A lot of people imagine that I build them as solid forms.

IB: By carving the exterior?

AS: Right. You couldn't fire them though—they would break if they were solid.

IB: Their hollowness can make them seem more alive.

AS: When I talk about the air moving in and out, those appendages which are snouts or spouts or phalluses or handles, or all of those things, those are ways for air to move in and out in both a practical and a symbolic way.

IB: Those suggestive forms are coated with unusual glazes and seductive surfaces.

AS: Sometimes I like to contradict the drooling, weird forms with lustrous satin skins. Other times I prefer to take the baroque ebullience of the form and flatten it out with a mousey matte glaze. In ceramics, there's a pause between building the pieces and applying the glazes. Because of the long time required for drying and firing, this can be months. When I come back to making the glaze decisions, I have the chance to reintroduce myself to the work. This little bit of space creates enough detachment that I can take more risks with the surfaces. Recently I've been experimenting with layering a bunch of white glazes that misfire just enough to make a blanket of pimples that can also read as puckered lace.

IB: The finished forms don't seem to fit in any one time period.

AS: Not giving it a fixed time is the same for me as trying not to fit into a single subject matter. Modernist sculpture and historical pottery offer similar potential for me. "Ceramic sculpture," that's a category I am not interested in. I also don't want to make "abstract sculpture." I don't like that category either. I want to play in the middle. I like addressing the idea of the vessel without taking it on as the only subject matter.

I began to work with clay because I wanted a material with a history but also a plasticity that would allow me to make anything. Clay provides an opportunity for building slowly, poking around, and figuring things out while finding what I want to make by making it, rather than thinking it and then making it. I want the pieces to embrace the contradictions that I see and feel life to be about.

(overleaf)
Studio view, New York, 1997
Hydrocal, acrylic paint skins,
found furniture

15

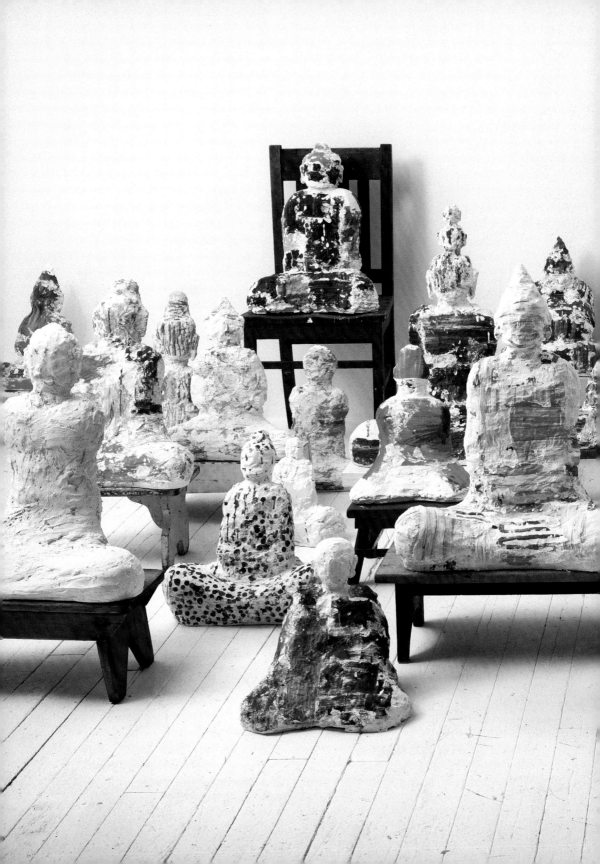

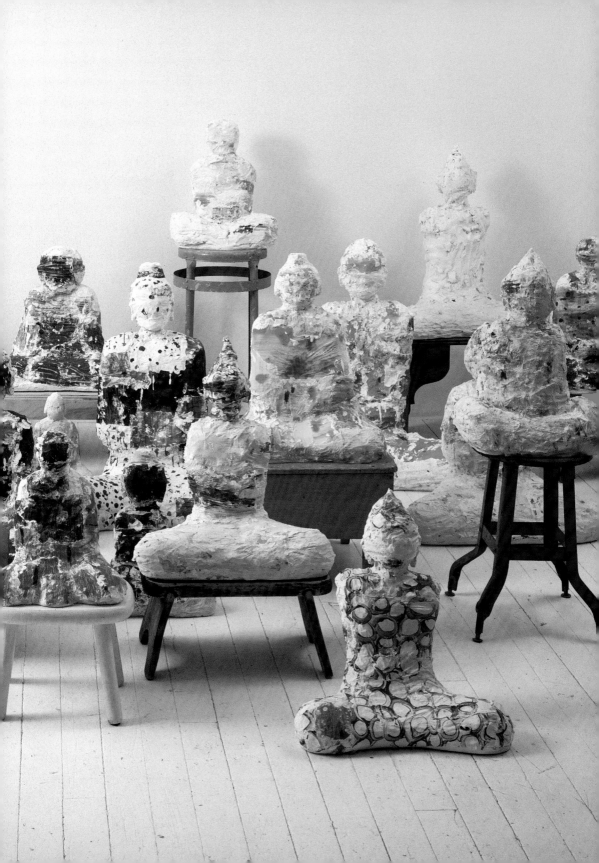

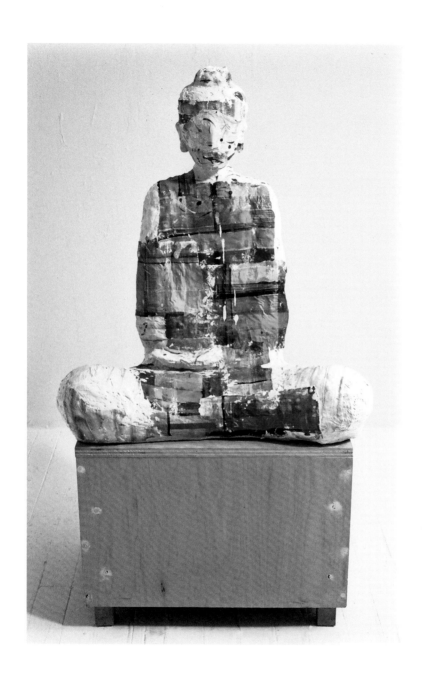

(this page, detail facing)
Madras Buddha, 1997
Hydrocal, acrylic paint skins,
plywood
45 x 25 x 17"
Collection of Les Firestein

(overleaf)
Once Removed, 1998
Cast paper, hydrocal
Overall dimensions variable

19

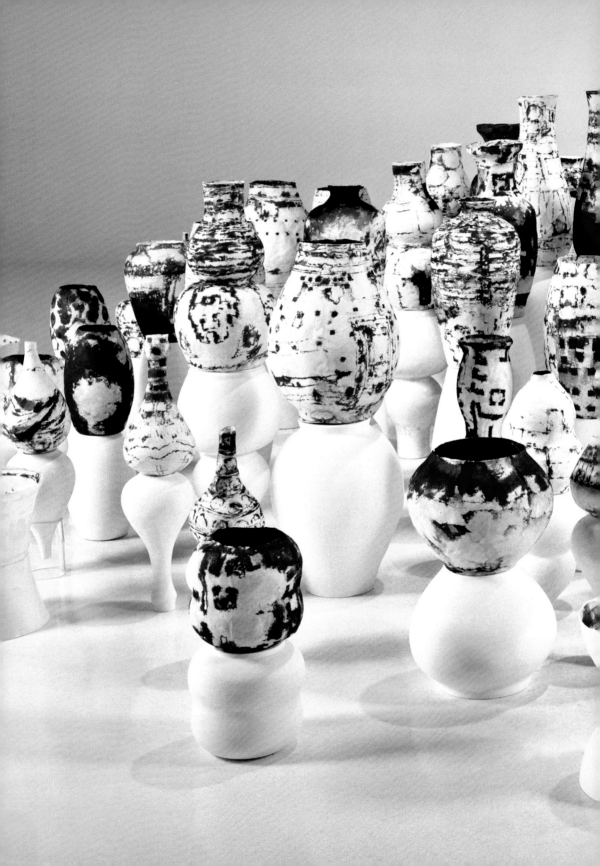

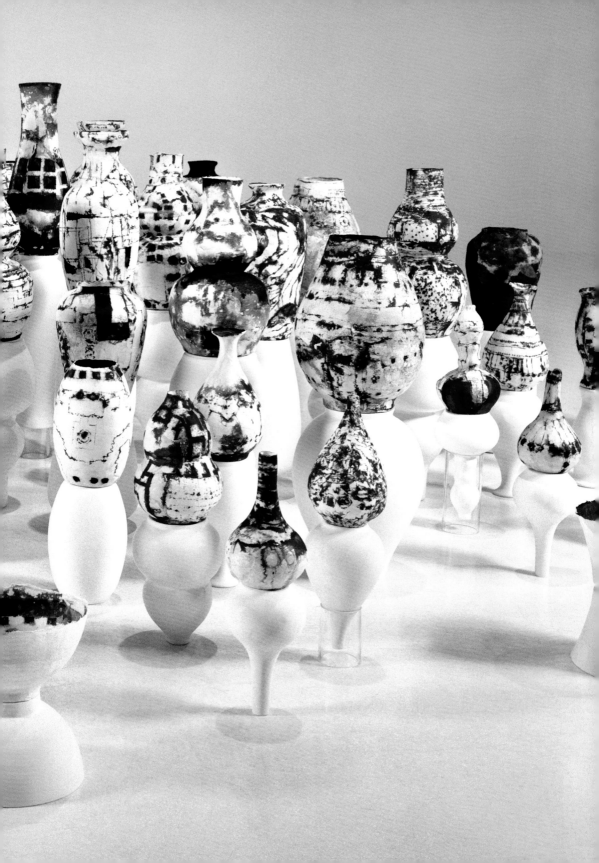

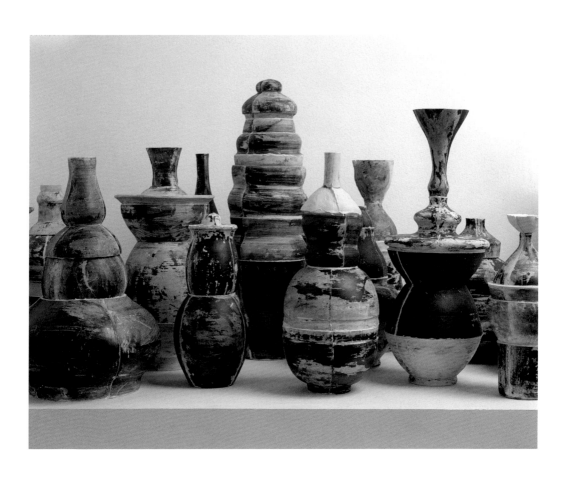

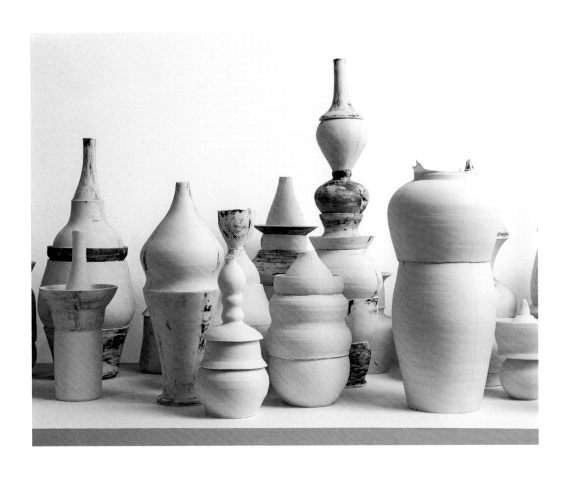

(details, this page and facing)
Building, 2003
Cast, constructed, glazed,
and fired porcelain
Overall dimensions variable
Installation views, Henry
Art Gallery, Washington
University, Seattle,
Washington, 2003

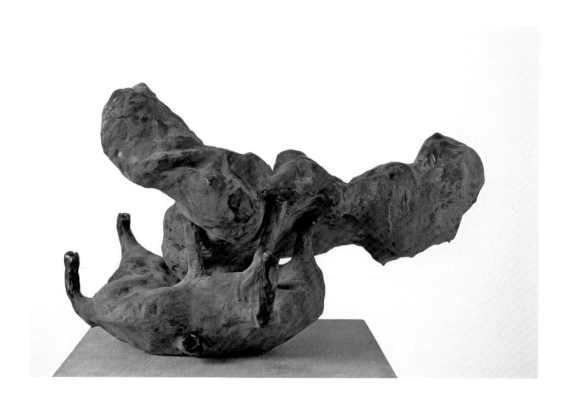

(this page and facing)
Humid Fantasy, 2006–07
Glazed ceramic, hydrocal, steel
44 x 20^1/$_4$ x 16^1/$_2$"
Collection of the artist

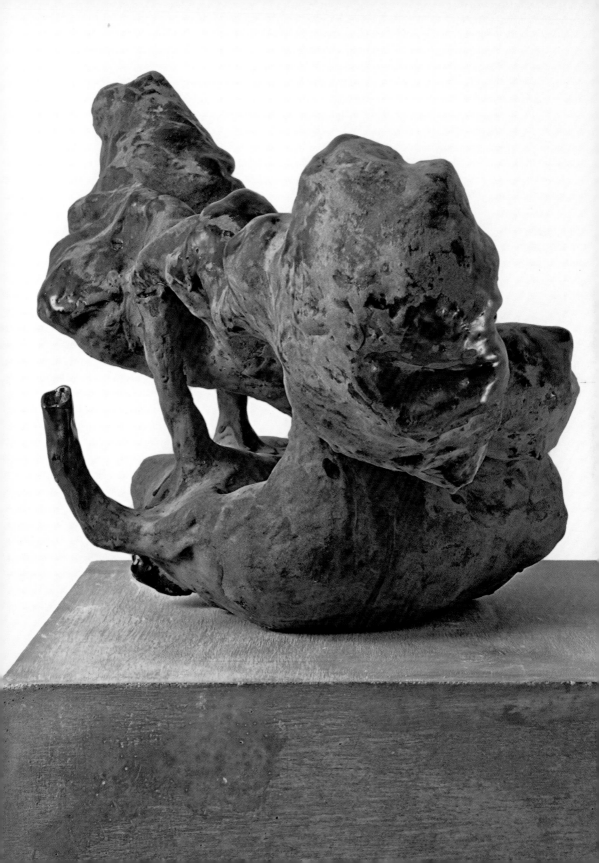

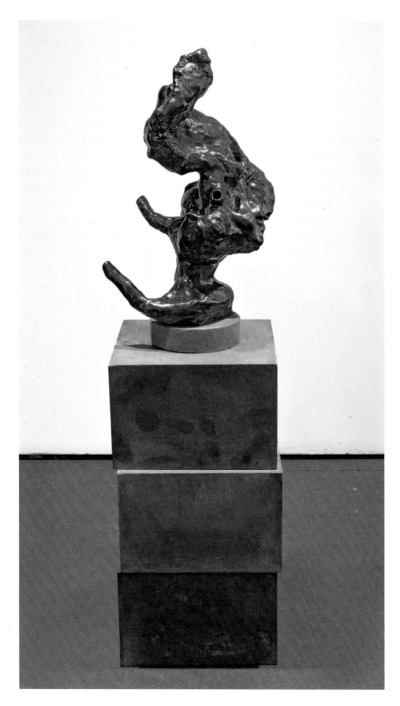

Way Out, 2007
Glazed ceramic, concrete
51 ½ x 14 x 14"
Collection of Bunty and
Tom Armstrong

(facing page)
Everything Seems to be
Something Else, 2007–08
Glazed ceramic, cast concrete,
steel
69 x 24 x 24"
Collection of Robert B. Geller

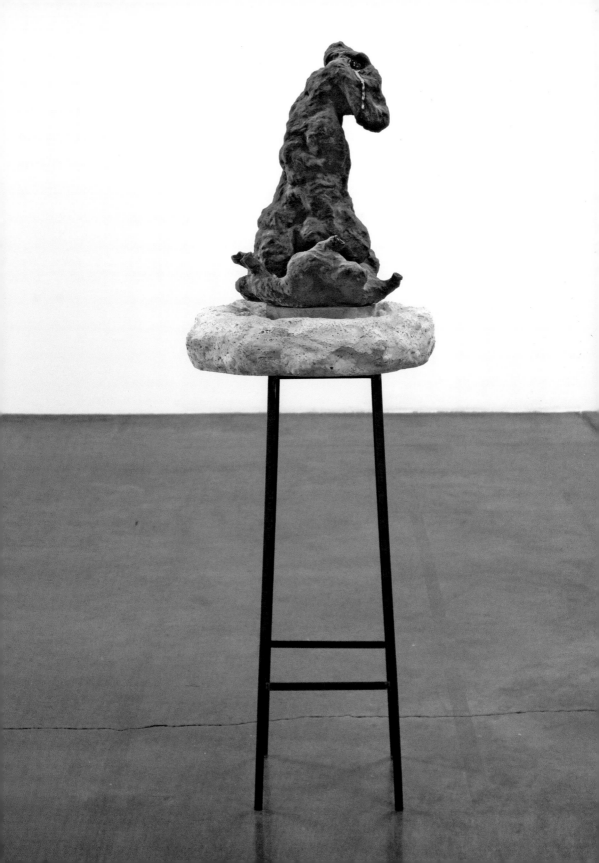

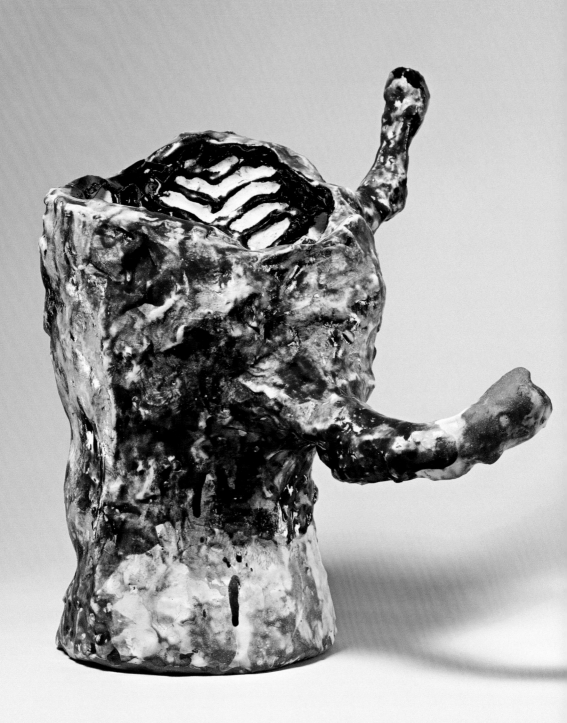

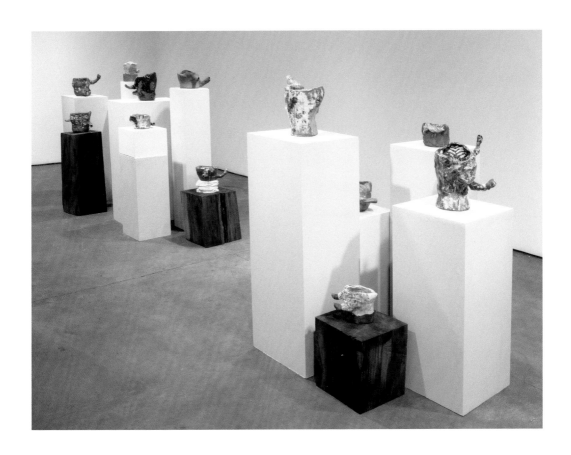

(facing page)
Y Wabi N, 2007
Glazed ceramic
13 x 13 x 11"
Whitney Museum of American Art,
New York
Purchase, with funds from Anne
and Joel Ehrenkranz, 2008.217

Installation view, *New Work*,
Elizabeth Harris Gallery, 2007

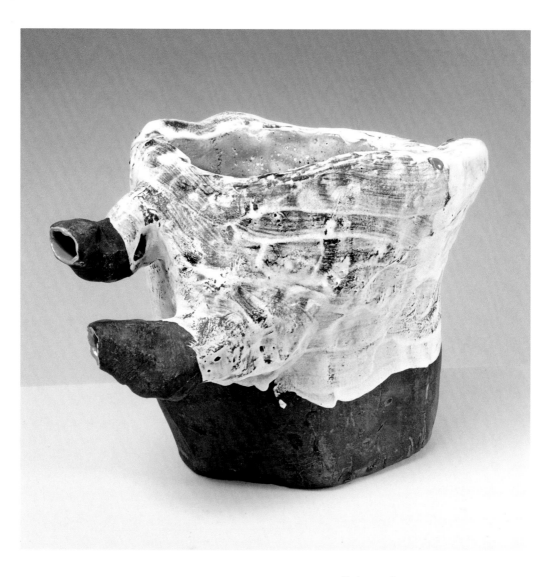

Y Wabi M, 2007
Glazed ceramic
6 x 8 x 7"
Collection of Dennis Freedman

(facing page)
Installation view, Walker Art Center,
Minneapolis, 2009
In foreground: *Anything & Always*, 2008
Glazed ceramic, bronze plate, cast concrete
47 1/4 x 16 x 14"
Courtesy of the artist and Jack Shainman
Gallery, New York

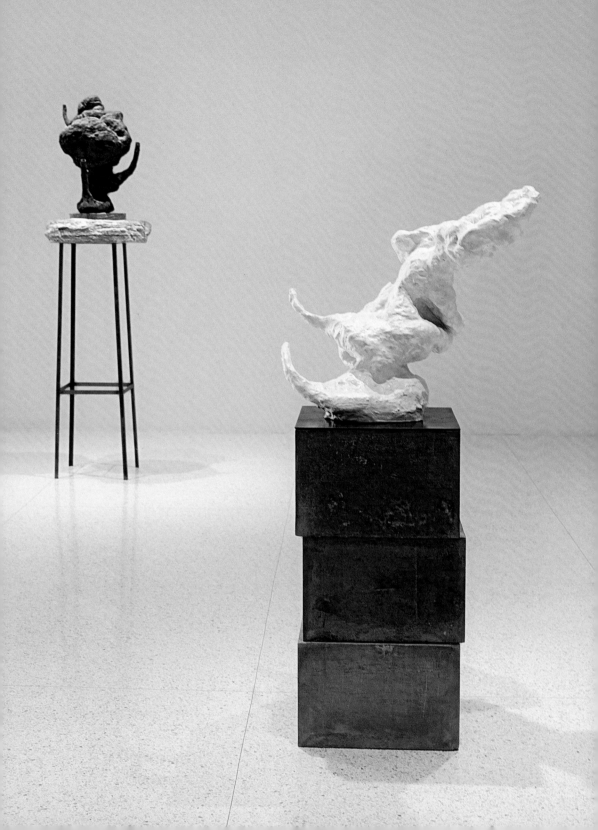

Up and Out, 2007
Glazed ceramic, steel, wood
69 x 18 x 18"
Mirvish Collection

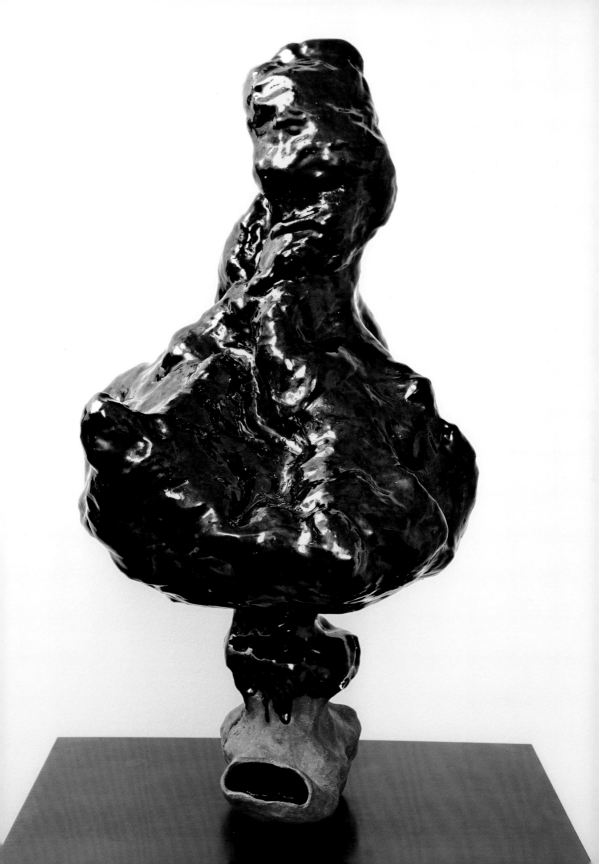

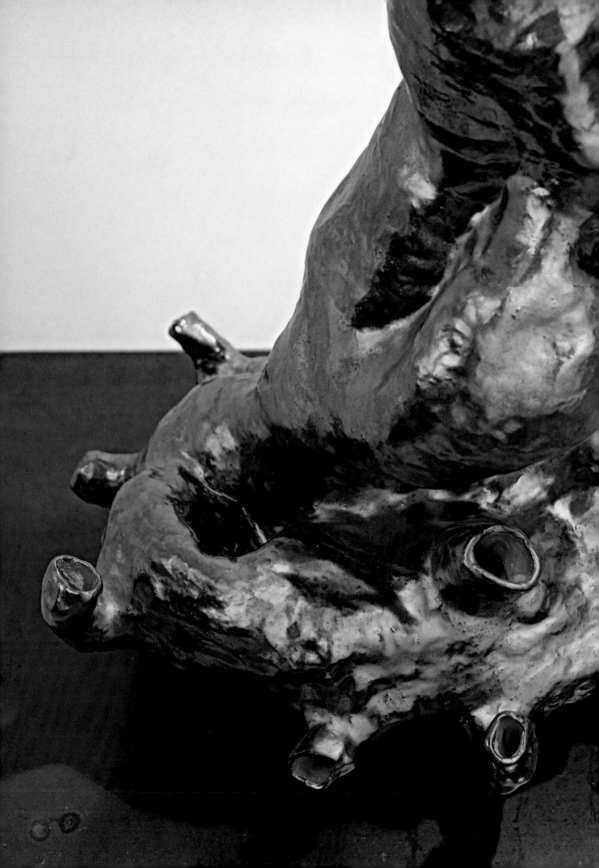

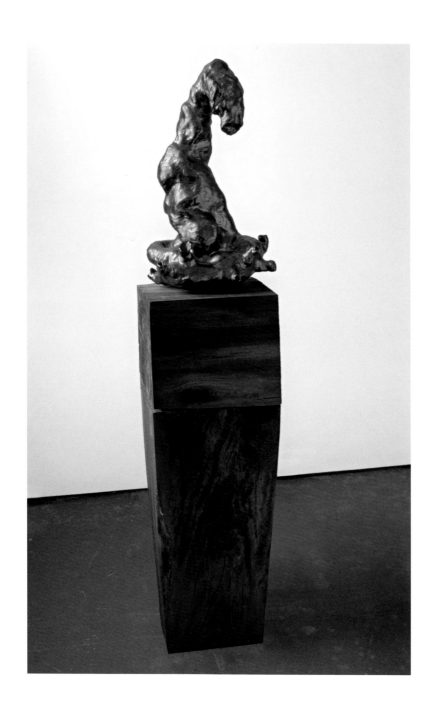

(this page, detail facing)
Loll, 2007
Glazed ceramic, hardwood
64 x 14 x 14"
Candace King Weir Foundation

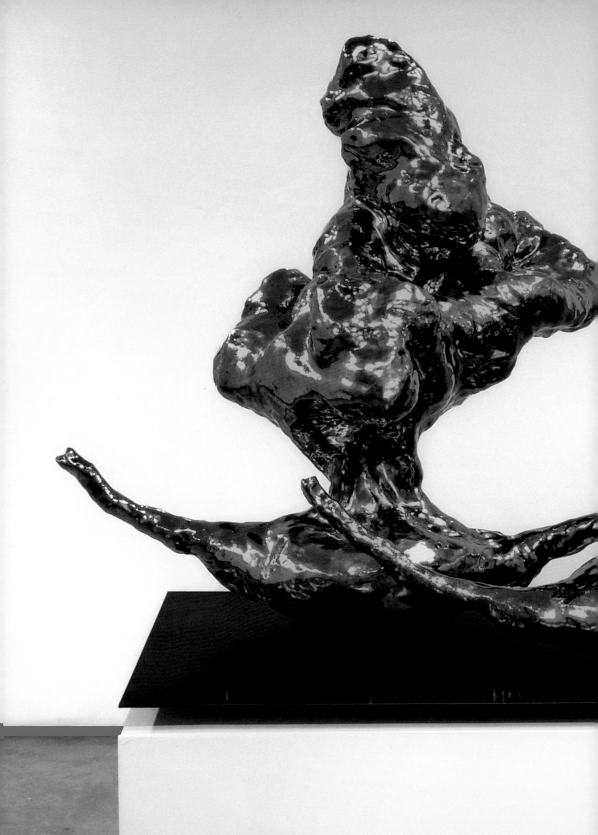

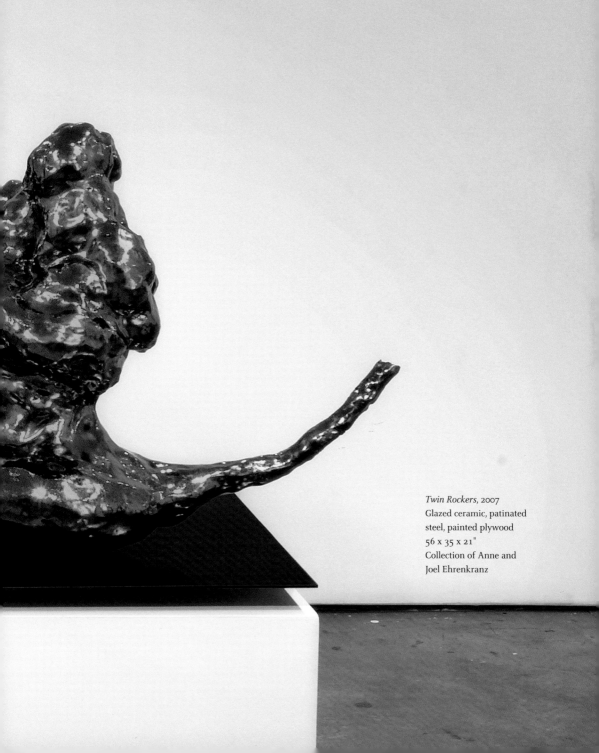

Twin Rockers, 2007
Glazed ceramic, patinated
steel, painted plywood
56 x 35 x 21"
Collection of Anne and
Joel Ehrenkranz

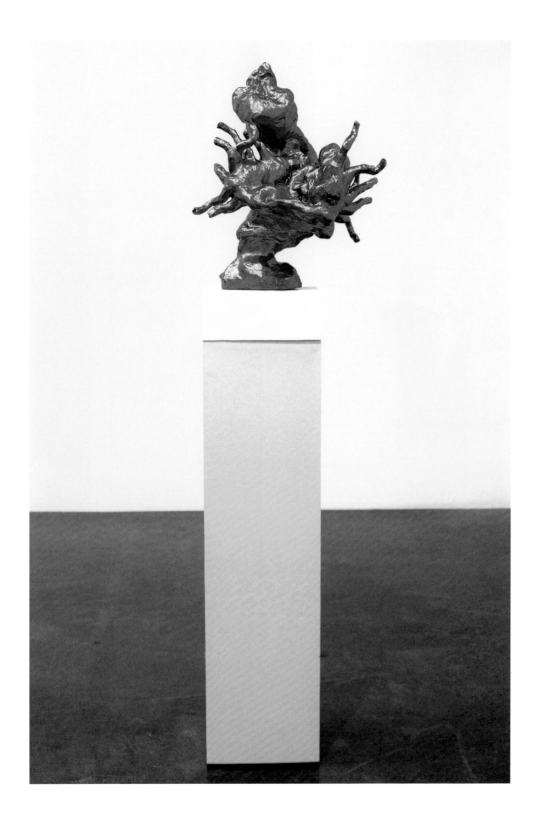

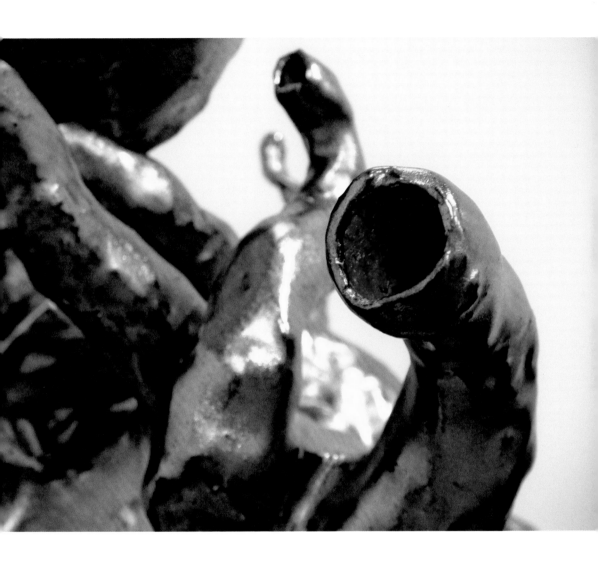

(facing page, detail above)
Even and Perhaps Especially, 2007
Glazed ceramic, hydrocal, painted wood
71 x 14 x 17 $^1/_2$"
Courtesy of the artist, Jack Shainman
Gallery, New York, and Shoshana Wayne
Gallery, Santa Monica

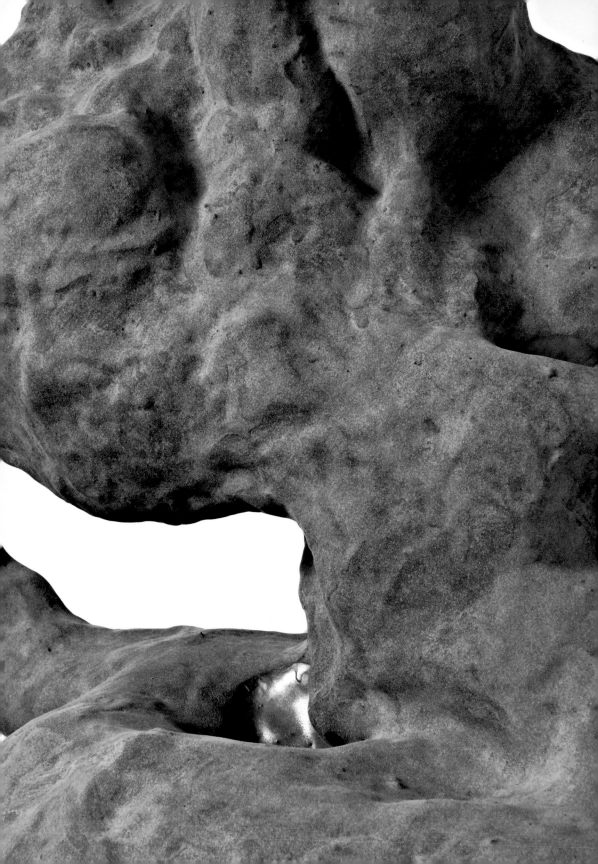

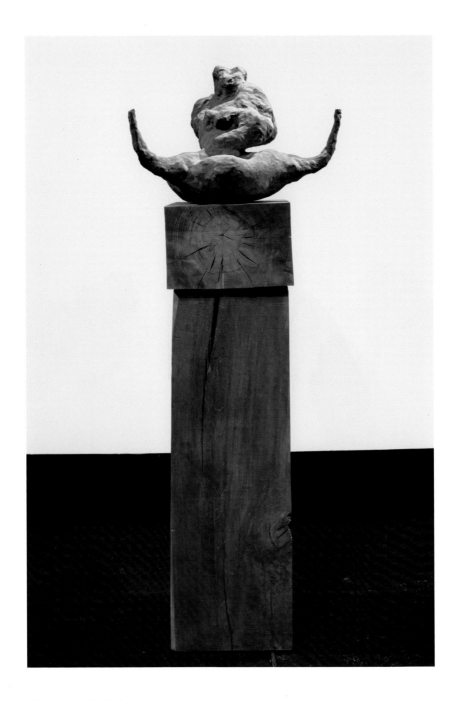

(this page, detail facing)
Up For Air, 2007
Ceramic, solid hardwood
65 $^1/_2$ x 23 $^1/_2$ x 29"
Courtesy of the artist and
Jack Shainman Gallery, New York

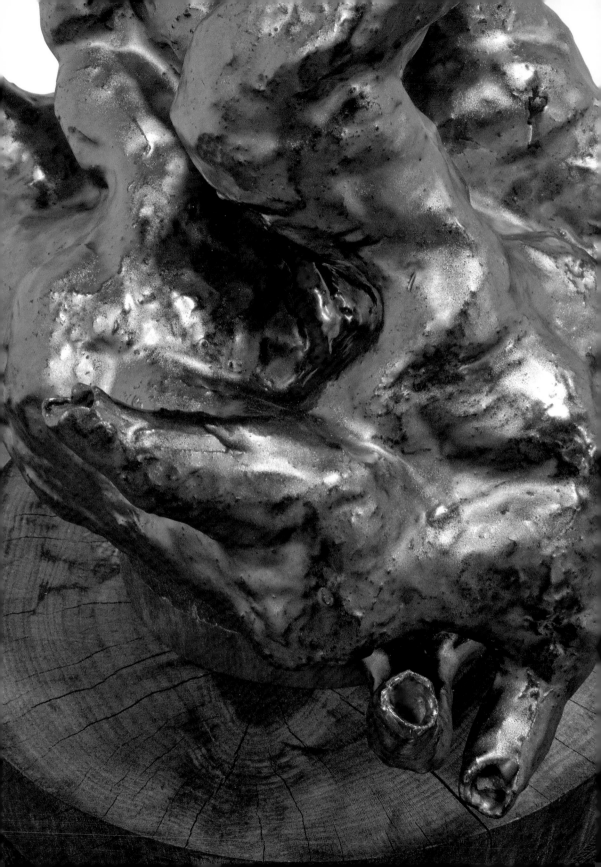

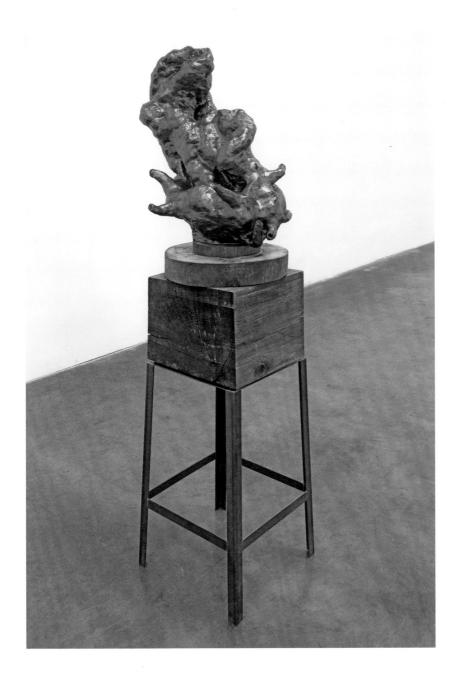

(this page, detail facing)
Rock In The Form Of A Big Breath &
A Stubborn Thought, 2007
Glazed ceramic, solid hardwood, steel
62 x 20 x 19"
Collection of Soo Jin Jeong-Painter and
Patrick Painter, Los Angeles

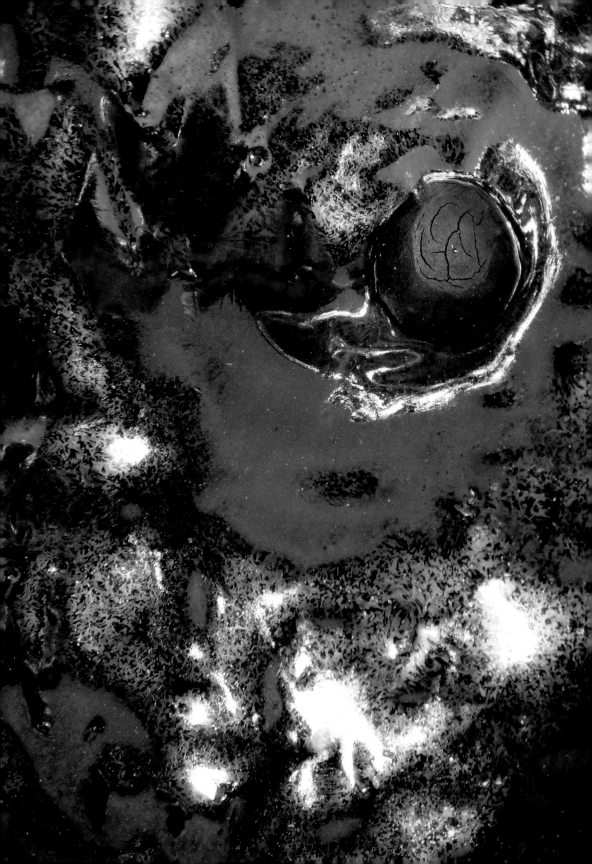

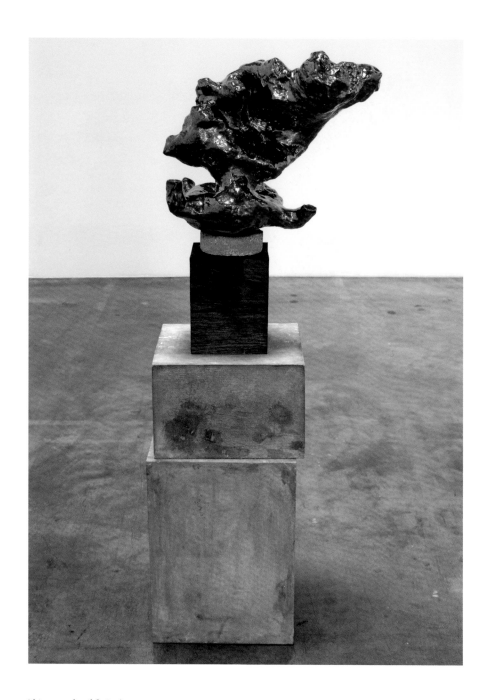

(this page, detail facing)
Blow By Blow, 2007
Glazed ceramic, cast concrete,
solid hardwood
$55 \frac{1}{2}$ x $20 \frac{1}{2}$ x 14"
Collection of Dina and Eitan Gonen

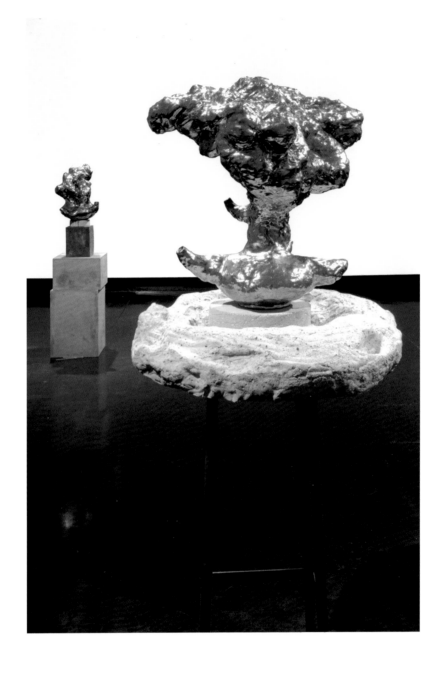

(this page, detail facing)
Elvis, 2008
Glazed ceramic, cast concrete, steel
63 x 29 x 26"
Courtesy of the artist and

Jack Shainman Gallery, New York

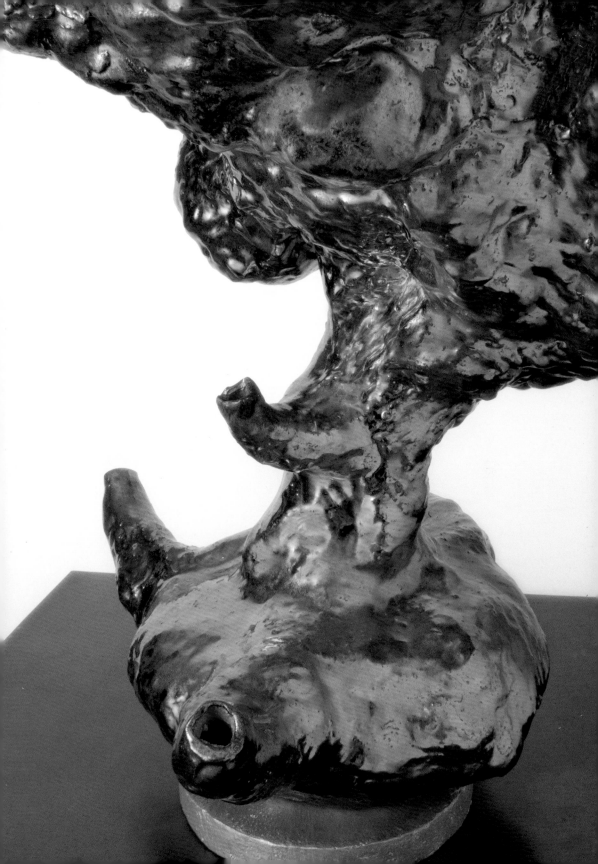

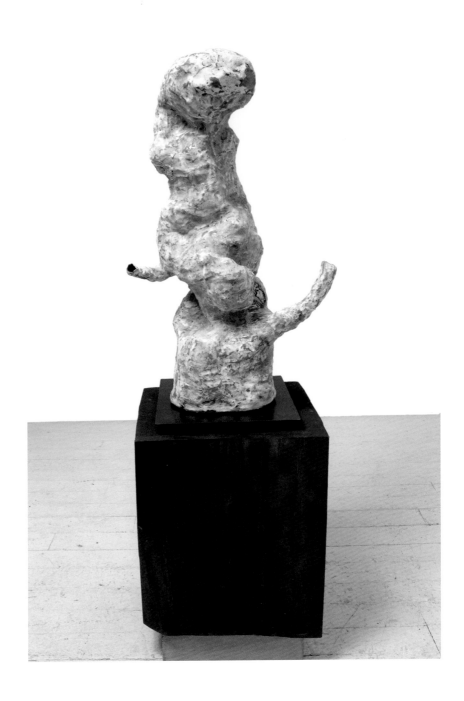

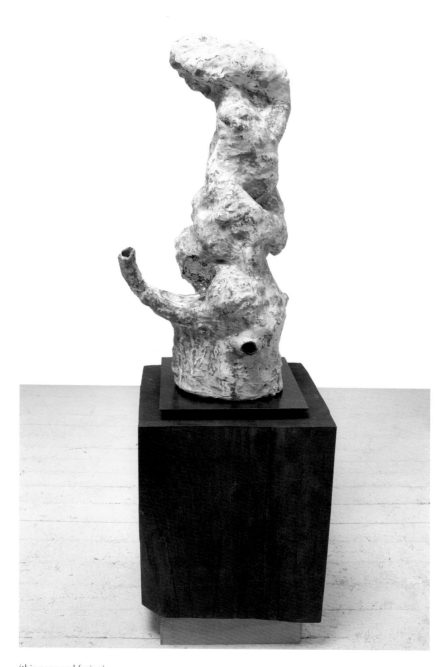

(this page and facing)
Some Do, 2008
Glazed ceramic, patinated steel, solid hardwood,
cast concrete
42 1/2 x 14 1/2 x 12 3/4"
Courtesy of the artist and Jack Shainman Gallery, New York

Pucker Up, 2007–08
Glazed ceramic, hydrocal,
painted wood
68 $^1/_2$ x 12 $^1/_2$ x 16"
Courtesy of the artist and
Shoshana Wayne Gallery,
Santa Monica

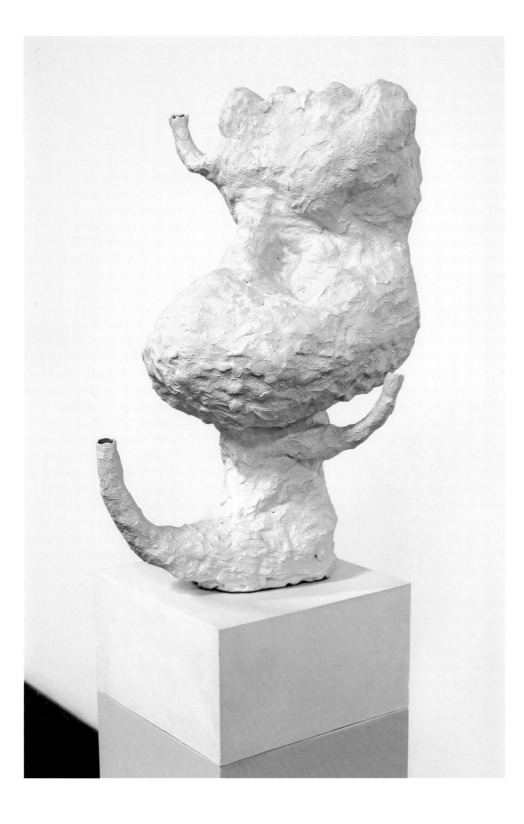

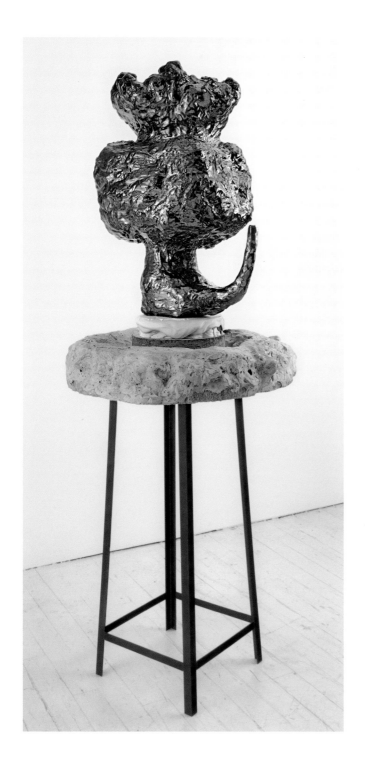

(this page, detail facing)
Tough Puff, 2008
Glazed ceramic, pigmented
hydrocal, plywood
65 x 26$\frac{1}{2}$ x 24"
Courtesy of the artist and Jack
Shainman Gallery, New York

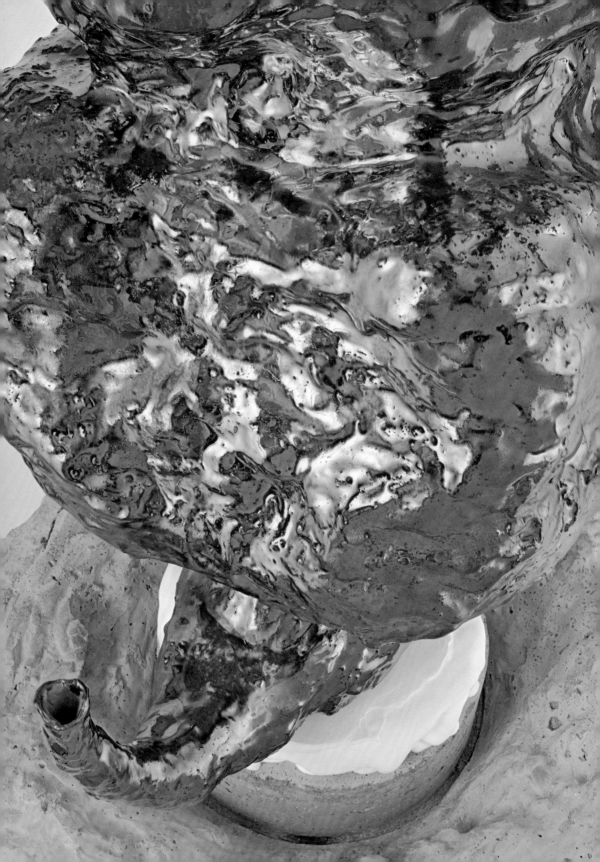

Other Than That, 2008
Glazed ceramic, pigmented
hydrocal, plywood
53 $^{1}/_{2}$ x 31 x 31"
Collection of Jack Shainman
and Claude Simard

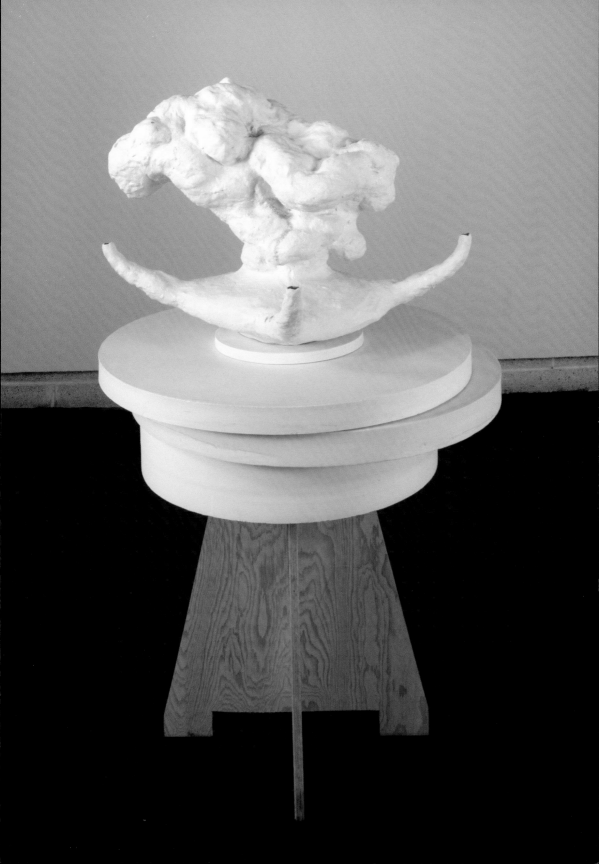

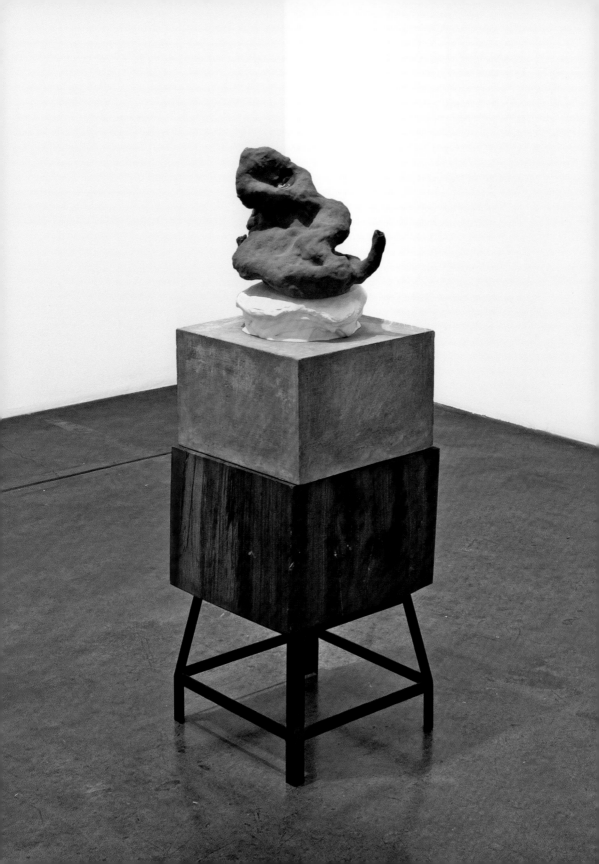

CHECKLIST

All works by Arlene Shechet
Dimensions listed in inches, h x w x d

1. *Humid Fantasy*, 2006–07
Glazed ceramic, hydrocal, steel
44 x 20 $^1/_4$ x 16 $^1/_2$
Collection of the artist

2. *Even and Perhaps Especially*, 2007
Glazed ceramic, hydrocal, painted wood
71 x 14 x 17 $^1/_2$
Courtesy of the artist, Jack Shainman
Gallery, New York, and Shoshana
Wayne Gallery, Santa Monica

3. *Blow By Blow*, 2007
Glazed ceramic, cast concrete,
solid hardwood
55 $^1/_2$ x 20 $^1/_2$ x 14
Collection of Dina and Eitan Gonen

4. *Rock In The Form Of A Big Breath
& A Stubborn Thought*, 2007
Glazed ceramic, solid hardwood, steel
62 x 20 x 19
Collection of Soo Jin Jeong-Painter
and Patrick Painter, Los Angeles

5. *See Sigh*, 2007
Glazed ceramic, hydrocal, cast concrete,
solid hardwood, steel
44 $^1/_2$ x 15 x 15
Courtesy of the artist and
Jack Shainman Gallery, New York

See Sigh, 2007
Glazed ceramic, hydrocal, cast
concrete, solid hardwood, steel
44$^1/_2$ x 15 x 15"
Courtesy of the artist and Jack
Shainman Gallery, New York

6. *Up For Air*, 2007
Ceramic, solid hardwood
65 $^1/_2$ x 23 $^1/_2$ x 29
Courtesy of the artist and
Jack Shainman Gallery, New York

7. *What I Heard*, 2007
Glazed ceramic, steel
58 x 19 x 20 $^1/_2$
Nerman Museum of Contemporary Art,
Johnson County Community College,
Overland Park, Kansas; gift of Marti
and Tony Oppenheimer and the
Oppenheimer Brothers Foundation

8. *Pucker Up*, 2007–08
Glazed ceramic, hydrocal, painted wood
68 $^1/_2$ x 12 $^1/_2$ x 16
Courtesy of the artist and Shoshana
Wayne Gallery, Santa Monica

9. *Some Do*, 2008
Glazed ceramic, patinated steel,
solid hardwood, cast concrete
42 $^1/_2$ x 14 $^1/_2$ x 12 $^3/_4$
Courtesy of the artist and
Jack Shainman Gallery, New York

10. *Other Than That*, 2008
Glazed ceramic, pigmented hydrocal,
plywood
53 $^1/_2$ x 31 x 31
Collection of Jack Shainman and
Claude Simard

11. *Elvis*, 2008
Glazed ceramic, cast concrete, steel
63 x 29 x 26
Courtesy of the artist and
Jack Shainman Gallery, New York

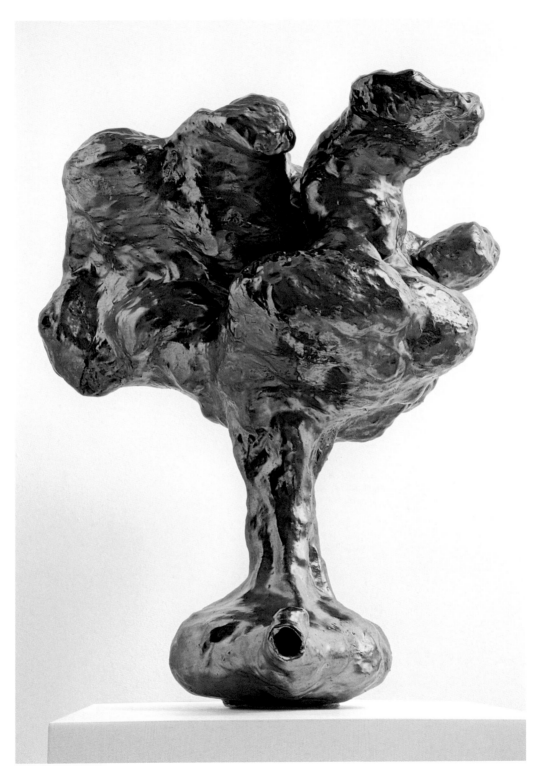

ARLENE SHECHET

Born in New York
Lives and works in New York

Education

M.F.A., Rhode Island School of Design, Providence, Rhode Island
B.A., New York University, New York

Solo Exhibitions

2009

Opener 18: Arlene Shechet: Blow By Blow, The Frances Young Tang Teaching
 Museum and Art Gallery, Skidmore College, Saratoga Springs, New York,
 September 26–January 3, 2010
Here and There, Museum of Contemporary Art, Denver, Colorado, July 16–
 January 16, 2010

2008

Now and Away, Shoshana Wayne Gallery, Santa Monica, California,
 February 16–March 15

2007

New Work, Elizabeth Harris Gallery, New York, September 6–October 6

2006

Thin Air, Sun Valley Center for the Arts, Ketchum, Idaho, April 9–June 2
Round and Round, Hemphill Fine Arts, Washington, D.C., January 7–February 25

2004

Deep Blooze Series, Hemphill Fine Arts, Washington, D.C., June 10–July 31
Out of the Blue, Shoshana Wayne Gallery, Santa Monica, California, May 8–
 June 19

2003

Turning the Wheel, installation commissioned for *The Invisible Thread:*
 Buddhist Spirit in Contemporary Art, Newhouse Center for Contemporary
 Art, Snug Harbor Cultural Center, Staten Island, New York, September 28–
 February 29, 2004
Building, Henry Art Gallery, University of Washington, Seattle, Washington,
 March 3–May 4

2002

Flowers Found, Elizabeth Harris Gallery, New York, April 18–May 24

Air Time, 2007
Ceramic, unique cast bronze,
steel, painted plywood
60 x 30 x 22"
Collection of Mark Pollack

2001
Puja, A/D Gallery, New York, March–July

2000
Galerie René Blouin, Montreal, Canada, May 6–June 10

1999
Mirror Mirror, Elizabeth Harris Gallery, New York, April 22–May 22

1998
Once Removed, Shoshana Wayne Gallery, Santa Monica, California, June 13–
 August 15

1997
Arlene Shechet: Sculpture and Drawing, Bernard Toale Gallery, Boston,
 Massachusetts, September 4–October 4
Arlene Shechet: Sculpture and Works of Paper, John Berggruen Gallery,
 San Francisco, California, March 6–April 5

1996
Shoshana Wayne Gallery, Santa Monica, California, July 12–August 31

1992
Bess Cutler Gallery, New York

1991
Payton-Rule Gallery, Denver, Colorado

1984
Bess Cutler Gallery, New York

1980
Minneapolis College of Art Gallery, Minneapolis, Minnesota

Selected Group Exhibitions

2009
feelers, Susan Hobbs Gallery, Toronto, Canada, June 27–August 15
New Works/Old Story, Contemporary Jewish Museum, San Francisco, California,
 February 27–June 2
Seriously Funny, Scottsdale Museum of Contemporary Art, Scottsdale, Arizona,
 February 14–May 24
New Now: Building the Museum Collection, Nerman Museum of Contemporary
 Art, Johnson County Community College, Overland Park, Kansas, January 23–
 June 19

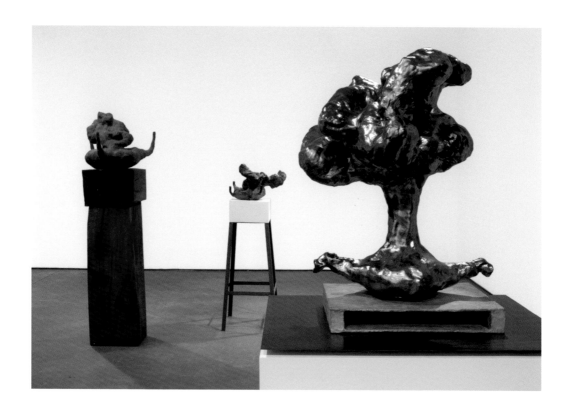

Dirt On Delight: Impulses That Form Clay, Institute of Contemporary Art, University of Pennsylvania, Philadelphia, Pennsylvania, January 15–June 21; traveled to: Walker Art Center, Minneapolis, Minnesota, July 11–November 29

Installation view, *New Work*, Elizabeth Harris Gallery, New York, 2007

2008
True Grit: Frames, Fixations & Flirtations, McColl Center for Visual Art, Charlotte, North Carolina, September 12–November 1
Landscapes of the Mind, United States Embassy, Beijing, China, August (permanent installation)
Neti Neti (Not This, Not This), Bose Pacia Gallery, New York, July 8–August 16
Grey, Dinter Fine Art, New York, June 19–August 1
Present Tense, Spanierman Modern Gallery, New York, June 12–August 2

2007
Shattering Glass: New Perspectives, Katonah Museum of Art, Katonah, New York, November 11–February 24, 2008
Written on the Wind: The Flag Project, Rubin Museum of Art, New York, September 14–February 11, 2008
Paths: Real and Imagined, Byrdcliffe Arts Colony, Woodstock, New York, June 9–October 8

Installation view, *Now & Away*,
Shoshana Wayne Gallery,
Santa Monica, California, 2008
In foreground: *Eye Level*,
2007–08
Glazed ceramic, solid cedar
hardwood, patinated steel,
cast bronze
48 x 20 x 20"
Los Angeles County Museum
of Art, Gift of Shoshana and
Wayne Blank (M.2008.259a-d)

2006

The Bong Show, or This Is Not a Pipe, Leslie Tonkonow Artworks + Projects,
New York, December 9–January 20, 2007

The Missing Peace: Artists Consider the Dalai Lama, Fowler Museum, University
of California, Los Angeles, California, June 11–September 10; traveled to:
Loyola University Museum of Art, Loyola University, Chicago, Illinois,
October 28, 2006–January 15, 2007; Rubin Museum of Art, New York, March
3–September 4, 2007; Emory Visual Arts Gallery, Emory University, Atlanta,
Georgia, September 29–October 27, 2007; Yerba Buena Center for the Arts,
San Francisco, California, December 1, 2007–March 16, 2008

2005

Faith, Real Art Ways, Hartford, Connecticut, October 8–January 28, 2006
Seven Artists, American Embassy, Hanoi, Vietnam, June 25–August 23, 2007
Somewhere Outside It, Schroeder Romero Gallery, New York, June 24–July 25

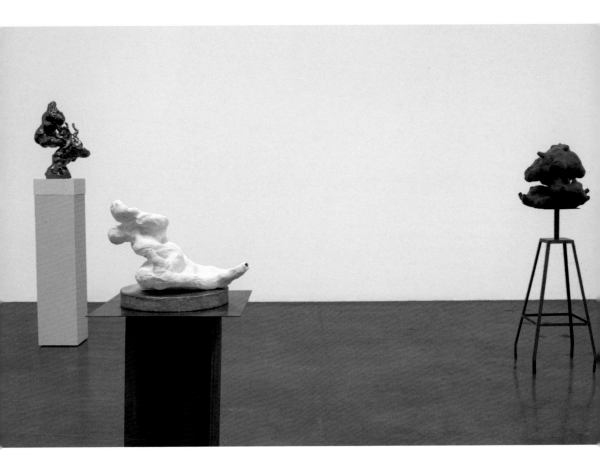

Monochrome Image, Elizabeth Harris Gallery, New York, June 2–July 22

Glass, Seriously, Dorsky Gallery Curatorial Programs, Long Island City,
 New York, April 24–June 27

2004

Bottle: Contemporary Art and Vernacular Tradition, The Aldrich Contemporary
 Art Museum, Ridgefield, Connecticut, September 19–April 10, 2005

Some Sculptures, Texas Gallery, Houston, Texas, August 17–September 11

The Buddha Project, Cleveland State University Art Gallery, Cleveland, Ohio,
 May 14–July 3

The Big Nothing, Institute of Contemporary Art, University of Pennsylvania,
 Philadelphia, Pennsylvania, May 1–August 1

2003

Stephen Mueller and Arlene Shechet, Van Brunt Gallery, New York,
 December 18–February 7, 2004

According With Nadelman: Contemporary Affinities, June Kelly Gallery,
 New York, July 1–August 1

Water, Water, Rotunda Gallery, New York, April 3–May 17

Mystic, Sandra and David Bakalar Gallery, Massachusetts College of Art
 and Design, Boston, Massachusetts, January 22–March 29

Water Mark / Inside, Ethel H. Blum Gallery, College of the Atlantic,
 Bar Harbor, Maine

2002

Line and Landscape, Ethan Cohen Gallery, New York, June 1–August 30

Curious Terrain, Elizabeth Harris Gallery, New York, January 3–February 2

2001

Ganesh, Galerie René Blouin, Montreal, Quebec, Canada, November 1–
 December 10

Rags to Riches: 25 Years of Paper Art from Dieu Donné Papermill, Kresge Art
 Museum, Michigan State University, East Lansing, Michigan, September 4–
 October 28; traveled to: Meyerhoff Gallery, Maryland Institute College of Art,
 Baltimore, Maryland, November 9–December 16; Marianna Kistler Beach
 Museum of Art, Kansas State University, Manhattan, Kansas, April 2–
 June 30, 2002; Heckscher Museum of Art, Huntington, New York, November
 23, 2002–January 26, 2003; Milwaukee Art Museum, Milwaukee, Wisconsin,
 April 11–June 22, 2003; Fort Wayne Museum of Art, Fort Wayne, Indiana,
 July 26–November 2, 2003

Digital Printmaking Now, Brooklyn Museum of Art, Brooklyn, New York,
 June 22–September 2

A Threshold of Spirit, Cathedral of St. John the Divine, New York, June 17–
 August 26

2000

The Living End, Boulder Museum of Contemporary Art, Boulder, Colorado,
 September 15–December 23

Religion: Contemporary Interpretations by Women, The Art Gallery, University
 of New Hampshire Durham, New Hampshire, January 25–April 25

Rapture, Bakalar and Huntington Galleries, Massachusetts College of Art and
 Design, Boston, Massachusetts, January 20–March 4

Mysticism and Desire, Patricia Hamilton Fine Art, Los Angeles, California

1999

Crafted Shadows, Franklin Parrasch Gallery, New York, June 5–August 27

Om, Dorsky Gallery, Long Island City, New York, February 16–April 6

Loaf, Baumgartner Galleries, Inc., New York

1998

In the Details, Barbara Gross Galerie, Munich, Germany, July 3–September 5

1997

Plastered, Shoshana Wayne Gallery, Santa Monica, California, May 3–June 7

1996

Bernard Toale Gallery, Boston, Massachusetts

Joanne Rapp Gallery, Scottsdale, Arizona

1995

Imaginary Beings, Exit Art, New York, December 2–January 27, 1996

Pure Painting, Boulder Museum of Contemporary Art, Boulder, Colorado,
 August 4–September 25

Mixed Media, Montgomery College, Rockville, Maryland

1994

Full House, 54 White Street, New York, December 1–17

1993

The Return of the Cadavre Exquis, The Drawing Center, New York,
 November 6–December 18

A–Z 0–9, E.S. Vandam Gallery, New York, October

1988

Bess Cutler Gallery, New York

Cydney Payton Gallery, Denver, Colorado

1987

American Ceramics: Now, Everson Museum of Art, Syracuse, New York, April 8–
June 28; traveled to: American Craft Museum, New York, July 31–October 18;
Crocker Art Museum, Sacramento, California, November 21–December 27;
DeCordova and Dana Museum and Park, Lincoln, Massachusetts,
January 14–March 12, 1989; Butler Institute of Art, Youngstown, Ohio, April
12–May 24, 1989; Sheldon Memorial Art Gallery, University of Nebraska,
Lincoln, Nebraska, June 15–August 15, 1989; Birmingham Museum of Art,
Birmingham, Alabama, September 6–November 15, 1989

1986

Beyond Clay, Queens College, The City University of New York, New York
Bess Cutler Gallery, New York
Natural Sources: Abstraction in Sculpture, P.S. 122, New York

1985

Organic Abstraction, Perimeter Gallery, Chicago, Illinois, November 22–
January 5, 1986
Small Works by Big Thinkers, Bess Cutler Gallery,
New York

1984

Three Dimensions, University of Texas at El Paso,
El Paso, Texas

1978

Young Americans: Clay and Glass, Tucson
Museum of Art, Tucson, Arizona, May 6–
June 11; traveled to: American Craft Museum,
New York, July 21–September 30

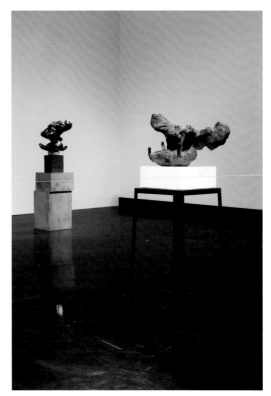

Installation view, *Blow by
Blow*, Tang Museum, Saratoga
Springs, New York, 2009

BIBLIOGRAPHY

Selected Books, Catalogues, and Brochures

Abbott, Helen, and Neil Liebman, eds. *The Flag Project: Contemporary Artists Celebrate the Opening of a New Museum.* Exhibition catalogue. New York: Rubin Museum of Art, 2007.

Alvis, Robert E. *Rapture.* Exhibition catalogue. Boston: Massachusetts College of Art, 2000.

Berry, Ian. *Arlene Shechet: Blow by Blow.* Exhibition catalogue. Saratoga Springs, New York: The Frances Young Tang Teaching Museum and Art Gallery at Skidmore College, 2010.

Brentano, Robyn, Olivia Georgia, Roger Lipsey, and Lilly Wei. *The Invisible Thread: Buddhist Spirit in Contemporary Art.* Exhibition catalogue. Staten Island, New York: Snug Harbor Cultural Center, 2004.

Brown, Elizabeth A. *Arlene Shechet: Building.* Exhibition brochure. Seattle: Henry Art Gallery, University of Washington, 2003.

Ellegood, Anne. *Arlene Shechet: Flowers Found.* Exhibition catalogue. New York: Elizabeth Harris Gallery, 2002.

Fyfe, Joe. *Om.* Exhibition catalogue. New York: Dorsky Gallery, 1999.

Glass, Seriously. Exhibition catalogue. New York: Dorsky Gallery, 2005. Essay by Lilly Wei.

Hyde, James. *Faith.* Exhibition catalogue. Hartford, Connecticut: Real Art Ways, 2006. Essays by James Elkins, David Kaufmann, and Thomas Zummer.

Keiter, Ellen. *Shattering Glass: New Perspectives.* Exhibition catalogue. Katonah, New York: Katonah Museum of Art, 2008. Essays by Tina Oldknow and Neil Watson.

Keough, Jeffrey. *Mystic.* Exhibition catalogue. Boston: Massachusetts College of Art, 2003. Essay by David D. Nolta.

Klein, Richard. *Bottle: Contemporary Art and Vernacular Tradition.* Exhibition catalogue. Ridgefield, Connecticut: The Aldrich Contemporary Art Museum, 2004.

Larson, Kay. *Arlene Shechet: Sculpture and Works of Paper.* Exhibition catalogue. San Francisco, California: John Berggruen Gallery, 1997.

The Missing Peace: Artists and the Dalai Lama. Exhibition catalogue. San Rafael, California: Earth Aware, 2006.

Nadelman, Elie. *Elie Nadelman: The Late Work.* New York: Salander-O'Reilly Galleries, 1999. Essays by Brandt Junceau and Klaus Kertess. Conversation with Arlene Shechet and Kiki Smith.

Nagy, Peter. *Mirror Mirror.* Exhibition catalogue. New York: Elizabeth Harris Gallery, 1999.

—. *Perfumed Manifestation: The Work of Arlene Shechet.* Exhibition catalogue. New York: Elizabeth Harris Gallery, 2007.

Olinsky, Frank. *Buddha Book: A Meeting of Images.* San Francisco: Chronicle Books, 1997.

Schaffner, Ingrid. *The Living End*. Exhibition catalogue. Boulder, Colorado: Boulder Museum of Contemporary Art, 2000.

Schaffner, Ingrid, Bennett Simpson, and Tanya Leighton. *The Big Nothing*. Exhibition catalogue. Philadelphia: Institute of Contemporary Art, University of Pennsylvania, 2004.

Schaffner, Ingrid, and Jenelle Porter. *Dirt On Delight: Impulses That Form Clay*. Exhibition catalogue. Philadelphia: Institute of Contemporary Art, University of Pennsylvania, 2009.

Takahashi, Mina, ed. *Rags to Riches: 25 Years of Paper Art from Dieu Donné Papermill*. Exhibition catalogue. New York: Dieu Donné Papermill, 2001. Essays by Chuck Close, Susan Gosin, Trudy V. Hansen, and Donna Stein.

Selected Articles and Reviews

"The Artist's Way." *O Magazine* (November 2001): 227.

Ash, Elizabeth. "Art in Embassies in Hanoi." *State MAGAZINE* (March 2006): 14.

Betts, Kristie. "Artflash, the End is Here." *Boulder Weekly* (28 September–4 October 2000).

Chandler, Mary V. "Pure Painting Exhibit is More Medium than Technique." *Rocky Mountain News* Denver (17 September 1995): 70.

Conner, Jill. "Nice and Wet." *artnet.com* (Spring 2003) http://www.artnet.com/ magazine/reviews/conner/conner6-10-03.asp.

Cotter, Holland. "Arlene Shechet." *New York Times* (21 May 1999): E32.

Dawson, Jessica. "Shechet, Sherwood and Bocchino at Hemphill." *Washington Post* (7 January 2006): C5.

De Vegh, Suzanne. "Arlene Shechet, New York." *Art Papers* (July/August 2008): 66.

Doubet, Ward. "Organic Abstraction." *New Art Examiner* 13 (February 1986): 53–54.

Douglas, Sarah. "'Unsuitable' Art Removed from Cathedral in New York." *TheArtNewspaper.com* (2001) http://www.theartnewspaper.com/news/article. asp?idart=6697.

Dubin, Wendy. *American Ceramics Now* 4 (1985): 72–73.

Dung, Dinh. "An American Artist Talks About Her Work and Buddhism." *Saigon Times Daily* (29 March 2006): 7.

Elliot, David. "Ganesh. Galerie René Blouin. Montreal." *Canadian Art* 19, no. 1 (March 2002): 88–89.

"Forum: On Motherhood, Art and Apple Pie." *M/E/A/N/I/N/G: Contemporary Art Issues* 12 (November 1992): 33.

Genocchio, Benjamin. "Really? It's All Made of Glass?" *New York Times* (30 December 2007).

Glackstern, J. "Many mysteries suggested at BMOCA's 'Living End.'" *Daily Camera* (15 October 2000).

Glueck, Grace. "An Object of Practicality, from the Inside and Out." *New York Times* (1 April 2005): E34.

Installation view, *Seriously Funny*, Scottsdale Museum of Contemporary Art, Scottsdale, Arizona, 2009

Goldman, Judith. *Art New England* (November 1985).

Goodman, Jonathan. "New York Reviews." *Sculpture Magazine* (July/August 2008): 77–78.

Gopnik, Blake. "Clay's Big Day." *Washington Post* (1 March 2009): M6–7.

Harrison, Helen. "Recycling Paper: Not Just Good for the Environment." *New York Times* (5 January 2003): 9.

Hirsch, Faye. "Arlene Shechet at Elizabeth Harris." *Art in America* 96, no. 2 (February 2008): 140.

—. "Working Proof." *On Paper* 2 (January/February 1998).

Johnson, Ken. "Arlene Shechet." *New York Times* (3 May 2002): E40.

—. "Art in Review: Elie Nadelman–'The Late Work.'" *New York Times* (10 September 1999).

Koplos, Janet. "Arlene Shechet at A/D." *Art in America* 90, no. 1 (January 2002): 109–110.

Larson, Kay. "Keeping the Faith." *ARTnews* (February 2000).

—. "The Missing Peace: Artists Consider the Dalai Llama." *Shambhala Sun* (November 2006).

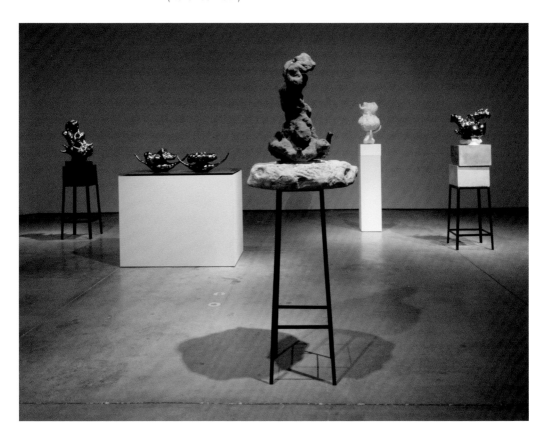

Levin, Kim. "Voice Choices." *Village Voice* (18 May 1999): 78.

Mahoney, J.W. "Arlene Shechet at Hemphill." *Art in America* 94, no. 9 (October 2006): 201–202.

McQuaid, Cate. "Arlene Shechet: Celebrating the Process of Creating." *Boston Globe* (18 September 1997): E1–E2.

M/E/A/N/I/N/G: Contemporary Art Issues, no. 19/20 (May 1996): 101.

Melrod, George. "Grace Notes." *Art & Antiques* 20 (September 1997): 29–30.

Morgan, Anne Barclay. "The Manifestation of Awareness." *Sculpture Magazine* (September 2004): 47–51.

Moser, Gabrielle. "Sarah Massecar, Sandra Meigs, Arlene Shechet, feelers." *Esse*, no. 67 (Fall 2009).

Newman, Morris. "Dalai Lama Concepts Inspire Works of Three Jewish Artists." *Jewish Journal* (10 August 2006).

Paglia, Michael. "Pigment of the Imagination." *Westword* (6 September 1995): 55.

Phillips, Autumn. "A Buddhist Concept on Paper." *Steamboat Pilot* Steamboat Springs, Colorado (12 August 2005): Arts Section Front Page.

Pierpont, Margaret. "Natural Mastery." *Natural Health* (October 2003): 160.

Pollack, Barbara. "Neti-Neti." *Time Out New York* (30 July–6 August 2008): 53.

Regan, Kate. "'Feelers' at Susan Hobbs, Toronto." *ARTnews* (November 2009): 125.

Ruth, Tara. "Double or Nothing: Mimicry in Contemporary Art Using Handmade Paper." *Hand Papermaking* 24, no. 2 (Winter 2009): 28–32.

Saltz, Jerry. "Gray: Critics' Pick." *New York Magazine Online* (23 July 2008).

Shulman, Ken. "Arlene Shechet." *ARTnews* 96, no. 11 (December 1997).

Smith, Kiki. "Artists' Choice–Arlene Shechet." *Art on Paper* 8, no. 2. (November/December 2003): 42–45.

Smith, Roberta. "Art in Review." *New York Times* (14 September 2007): E41.

—. "Crucible of Creativity, Stoking Earth Into Art." *New York Times* (20 March 2009): C25, C28.

—. "Why Craft Never Was a Four-Letter Word." *New York Times* (18 April 2009): C5.

Strouse, Allen. "Arlene Shechet's Military Base." ArtInfo.com (11 December 2007).

Tagore, Sundaram. "Facing East: American Artists' Encounters with India." *Art India: The Arts News Magazine of India* (April 1999): 55–57.

Temin, Christine. "Perspectives: Assorted Artists Capture 'Rapture.'" *Boston Globe* (2 February 2000): D1.

—. "Perspectives: 'Mystic' Exhibit Has Magic." *Boston Globe* (5 March 2003): C1.

ACKNOWLEDGMENTS

This catalogue, the eighteenth volume in our ongoing Opener series of artist projects, documents the last three years of work by artist Arlene Shechet. The series is made possible with continuing support from the New York State Council on the Arts, the Overbrook Foundation, and the Friends of the Tang. Special thanks to Dina and Eitan Gonen, Soo Jin Jeong-Painter and Patrick Painter, Nerman Museum of Contemporary Art at Johnson County Community College, Jack Shainman Gallery, Shoshana Wayne Gallery, and the artist, for their generous loans to the exhibition.

The entire staff of the Tang Museum contributed to this project—thanks to Kristen Boyle, Ginger Ertz, Torrance Fish, Megan Hyde, Elizabeth Karp, Susi Kerr, Gayle King, Chris Kobuskie, Ryan Lynch, Patrick O'Rourke, Lori Robinson, Barbara Schrade, Kelly Ward, and Tang Director John Weber for their unflagging dedication to this series. Thanks also to our hard working installation crew: Sam Coe, Rob Goodale, Jack Schaefer, Shawn Snow, and Jay Tiernan.

Thanks to Bethany Johns, who designed this book with a great affinity for the spirit of Arlene's work, and to the many photographers whose work is included on these pages.

Thanks to Jay Rogoff for his text editing and to students Francesca Fanelli, Griffin Ganon, Jessica Hass, Jordan Klein, Danika Lichtig, Ripley Sager, and Brooke Williams for their great energy and hard work. Thanks to Katie Rashid, Brooke Mellen, Joeonna Bellorado-Samuels, Sabrina Vanderputt, Claude Simard, and Jack Shainman at Jack Shainman Gallery in New York, and to Kerry O'Bryan, Wayne Blank, and Shoshana Blank at Shoshana Wayne Gallery in Santa Monica for their steady and ever-present support throughout. Thanks to Arlene's assistant Stephanie Gonzalez-Turner for her assistance with images and questions.

The project let us create and host the first of the Tang Museum's Alfred Z. Solomon Residencies to welcome an artist to engage with the studio art department at Skidmore, and we thank Arlene for her time and dedication to our students. Thanks to ceramics professor Leslie Ferst, who led the residency, and to the students for their work in the studio and at the museum, thinking and making alongside Arlene.

Our greatest thanks to Arlene for letting us bring together this body of work at the Tang. Arlene regularly pushes against constraints in her studio, whether material categories, or conceptual traditions, or conventional themes. Her life as an artist provides a model that encourages freedom, risk, provocation, and generosity in sharing those experiments with others. The lessons I have learned during the development of this project have challenged my own ways of working, and I will hold those lessons near to me for a long time to come.
—IAN BERRY

I have had a wonderful experience working on this project, and many people and institutions have contributed a great deal of time, energy and resources to making it happen. I cannot name all of them but feel deep gratitude for every effort. My family, Mark, Sonia, and Will, have been present for me at every turn with love, encouragement, patience, and proofreading. The cushion and comfort of their support enables me to live somewhat dangerously in the s tudio. I owe them everything.

At different times over the course of the last four years Lesley Day, Mike Nedich, and Stephanie Gonzalez-Turner have assisted me in the studio. Their work has required lots of heavy lifting, good humor, and inspiration. Their help has been essential. It is my very good fortune to have support from Jack, Claude, Katie and their great team at Jack Shainman Gallery, and Shoshana, Wayne, and Kelly at Shoshana Wayne Gallery. These business relationships have evolved into friendships. I hold them dear and thank them for their dedication. A special thank you to John Weber and the terrific staff at the Tang Museum, who have been extremely attentive and professional in every way.

Finally, none of this would be happening without Ian Berry's tremendous energy and enthusiasm. Working with him on the exhibit, the catalogue, and the Solomon Residency has been an important and elucidating experience for me. I have enjoyed and benefited from our many conversations, his inquiring mind, and his great eye. I admire him as an original thinker and a curator who is a friend of artists. —ARLENE SHECHET

This catalogue accompanies the exhibition

OPENER **18**
ARLENE SHECHET: *BLOW BY BLOW*

The Frances Young Tang Teaching Museum and Art Gallery at Skidmore College
Saratoga Springs, New York
September 26, 2009–January 3, 2010

The Frances Young Tang Teaching Museum and Art Gallery
Skidmore College
815 North Broadway
Saratoga Springs, New York 12866
T 518 580 8080
F 518 580 5069
www.skidmore.edu/tang

This exhibition and publication are made possible in part with public funds from the New York State Council on the Arts, a state agency, The Overbrook Foundation, and the Friends of the Tang.

© 2010 The Frances Young Tang Teaching Museum and Art Gallery
ISBN 978-0-9821486-1-7
Library of Congress control number 2010923188

All images reproduced in the catalogue, unless otherwise noted, are copyright of the artist.

Photography: Front cover, pages 2, 4, 24, 25, 26, 29, 30, 33, 34, 35, 36–37, 40, 44, 47, 48, 49, 52, 53, 58, 61: Cathy Carver
Pages 9, 10, 16–17, 18, 19, 20-21: John Behrens
Pages 13, 27, 38, 39, 43, 45, 51, 56, 62: Courtesy of Shoshana Wayne Gallery, Santa Monica, California
Page 22, 23: Courtesy of the Henry Art Gallery
Page 28: Sheldan C. Collins, Courtesy of Whitney Museum of American Art, New York
Page 31: Courtesy of Walker Art Center
Pages 41, 46, 55, and 65: Arthur Evans
Page 42: Joey Kotting
Page 68: Claire Warden, Courtesy of Scottsdale Museum of Contemporary Art, Scottsdale, Arizona

Front cover:
Way Out, 2007 (detail)
Glazed ceramic, concrete
51 1/2 x 14 x 14"
Collection of Bunty and Tom Armstrong

Back cover:
Installation view, *Now & Away*, Shoshana Wayne Gallery, Santa Monica, California, 2008

Page 1:
Artist's newspaper clipping
Courtesy of the artist

Page 2:
Swoon, 2006 (detail)
Glazed ceramic, hydrocal, cast concrete, and steel
61 1/2 x 18 x 18"
Private Collection

This page:
Artist's newspaper clipping
Courtesy of the artist

Designed by Bethany Johns / Printed in Germany by Cantz